LLANDUDNO

HISTORY TOUR

MARKET

WEN
AKERY
LEON
355
RLEY
ROVISION
NDER

Map contains Ordnance Survey data © Crown Copyright and database right [2015]

First published 2015

Amberley Publishing
The Hill, Stroud,
Gloucestershire, GL5 4EP
www.amberley-books.com

Copyright © John Lawson-Reay, 2015

The right of John Lawson-Reay to be
identified as the Author of this work
has been asserted in accordance with
the Copyrights, Designs and Patents
Act 1988.

ISBN 978 1 4456 4856 9 (print)
ISBN 978 1 4456 4857 6 (ebook)

British Library Cataloguing in
Publication Data.
A catalogue record for this book is
available from the British Library.

Typesetting by Amberley Publishing.
Printed in Great Britain.

INTRODUCTION

Llandudno is an ancient settlement that was transformed into an elegant bathing resort in the Victorian era.

The Mostyn family were prime movers of the scheme, assisted by a parliament that sanctioned eviction of villagers from seafront sites essential to the Mostyns' development plans. The fashionable new resort flourished, with the *London Illustrated Times* noting in 1862, 'Nor is it wonderful to us that this place should increase, for, of all the watering-places which stud our coast, there is no lovelier place than this.' Yet our illustrious London reporter cautioned prospective home-county holidaymakers, 'Visitors here are not of exactly the same class as that which is found on the southern coast ... at every step you hear the dialect of the North!'

With its beautiful bay framed by twin limestone headlands, Victorian guidebooks referred to Llandudno as the 'Naples of the North'. The 1854 opening of the town's first seaside hotel fortunately coincided with a rapid expansion of both photography and railways. While photographic images advertised attractive aspects of Llandudno far and wide, the railway system made it ever easier for holidaymakers to enjoy the elegant architecture and picturesque scenery for themselves.

Trains first reached Llandudno in 1858 and along with holidaymakers arrived pioneering photographers. Roger Fenton (1816–69), Thomas Edge (1820–1900), Francis Bedford (1816–94), James Cornaby (b. 1821) and William Silvester Laroche (b.1840) all came to Llandudno on photographic missions, and Edge settled permanently. A native of Preston, Thomas Edge was originally engaged by the London Stereoscopic Co. to record images of picturesque parts of Britain. His

cameras were wooden, tripod-mounted affairs with dual lenses casting twin images on a glass plate. The resulting stereocards were viewed through a simple binocular device, and the earliest photographs of Llandudno included here come from these stereo pictures published by Edge and his pioneering colleagues.

Unfortunately, after an initial burst of enthusiasm, the development of Llandudno slowed. As the Victorian era came to a close in 1901 the neighbouring resort of Colwyn Bay began to eclipse Llandudno's importance as both a holiday resort and a commercial centre. The Mostyn family's policy of selling property leasehold rather than freehold was blamed for strangling the town's expansion and Llandudno Council grew increasingly concerned.

As the twentieth century unfolded the Mostyn family became less and less directly involved in the affairs of the town. In 1935 the Mostyns left Gloddaeth Hall and with the death, at Bodysgallen, of Ieuan Lloyd Mostyn in 1966 the family's residency in Llandudno finally ended. Some feared as absentee landlords Mostyn Estates might concentrate more on short-term commercial profitability and less on investing in Llandudno's long-term development.

In the 1970s and '80s, old established family shops began to disappear from Mostyn Street to be replaced by chain stores. In the 1990s the Pier Pavilion burnt down and was abandoned; in the 2000s the town's historic grammar school was replaced by a supermarket. Most of the Victorian railway station was demolished and Llandudno's beautiful bay was filled with industrial wind turbines but, fortunately, there has also been good news. On Gloddaeth Street, the Palladium has been wonderfully restored and in Mostyn Street an attractive retail arcade replaced an ugly concrete shopping centre while down on the seafront the Art-Deco masterpiece, Villa Marina, now proudly proclaims its unique architectural importance after years of decline and neglect.

ACKNOWLEDGEMENTS

My thanks to Christopher Draper, well-known author, for his research and contribution to the project, which has made this book both entertaining as well as informative.

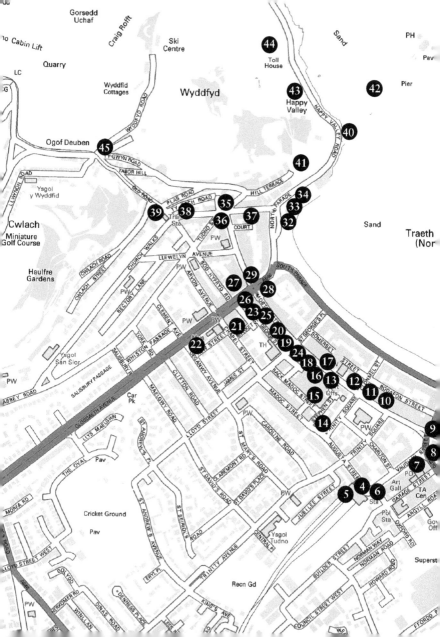

Ormes Bay
or
Llandudno Bay

gledd
ore)

LLANDUDNO

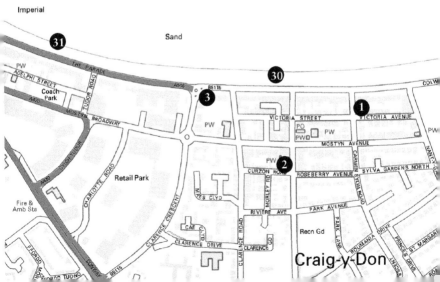

Imperial

Sand

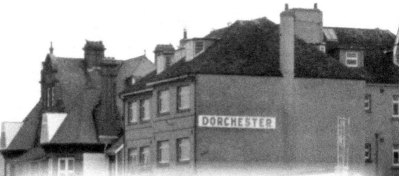

1. ASCOT HOTEL, PROMENADE

Erected in the 1870s, Ascot stood alone for many years at the eastern end of the parade. Following the June 1884 sale of the Craig-y-Don Estate, considerable commercial and residential development took place behind Ascot, but this remained a quieter, rather isolated end of the promenade. Despite successive owners promoting this aspect with a positive spin, tourists increasingly opted for more central accommodation. In March 1974 the Ascot Hotel was demolished and replaced by Ascot Court, a block of flats of breathtaking ugliness. Although the neighbouring, rather later, Bedford and Dorchester hotels subsequently suffered the same fate, their replacements at least attempted to respect the town's predominantly Victorian architecture.

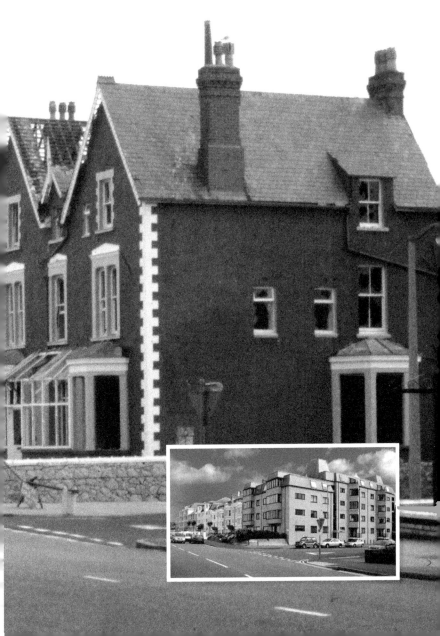

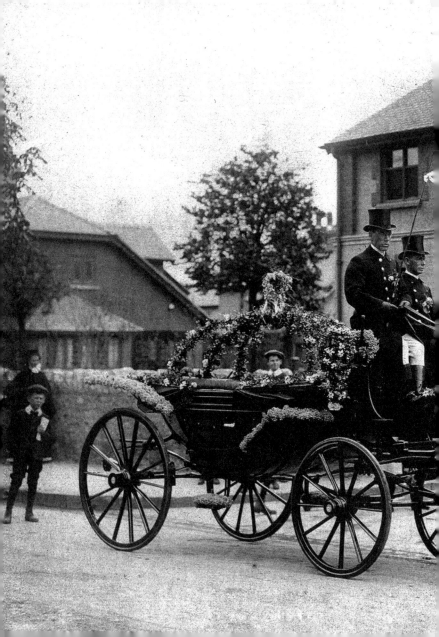

2. JARVIS & WOODYATT LIVERY STABLES, QUEEN'S ROAD

In 1902 Chester-born market gardener Herbert Jarvis and his business partner, Worcestershire-born George Woodyatt, opened their purpose-built livery stables in Craig-y-Don. Herbert's son was employed as a carriage driver and continued the partnership after his father's death in 1904. Although the mews was soon converted to serve as a motor garage, much of its original character has been preserved.

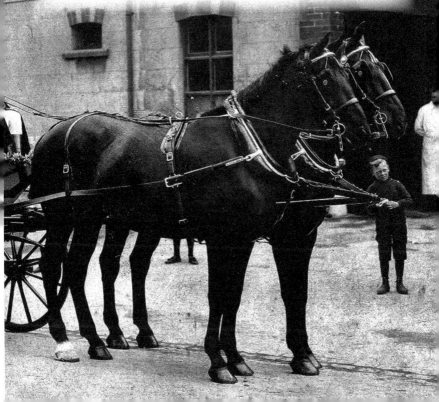

3. PUTTING GREEN, EAST PARADE

Until October 1899 this site was occupied by Tyn-y-Ffrith, the picturesque, tumbledown thatched smallholding of John Roberts. After holding out against avaricious developers for half a century, the occupants were defeated by 'health and safety' when the authorities insisted that the cottage's lack of connection to the sewers could only be remedied by demolition. Throughout most of the twentieth century Tyn-y-Ffrith's former pasture served as a popular putting green, but in 2002 the developers finally had their way and replaced the grass with 'Cwrt Sant Tudno', a massive block of sixty-six retirement flats.

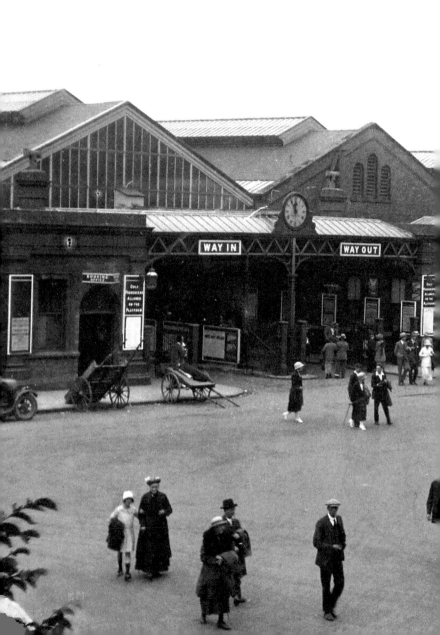

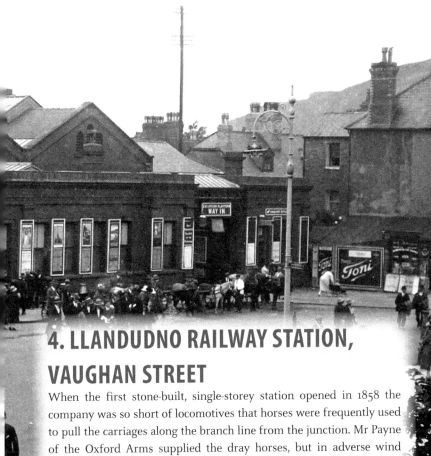

4. LLANDUDNO RAILWAY STATION, VAUGHAN STREET

When the first stone-built, single-storey station opened in 1858 the company was so short of locomotives that horses were frequently used to pull the carriages along the branch line from the junction. Mr Payne of the Oxford Arms supplied the dray horses, but in adverse wind conditions passengers were also obliged to push! In 1891 the station was rebuilt in fine red sculptured Ruabon brick and greatly enlarged, but the result was functional rather than impressive, inspiring passengers with little sense of excitement on arrival or departure.

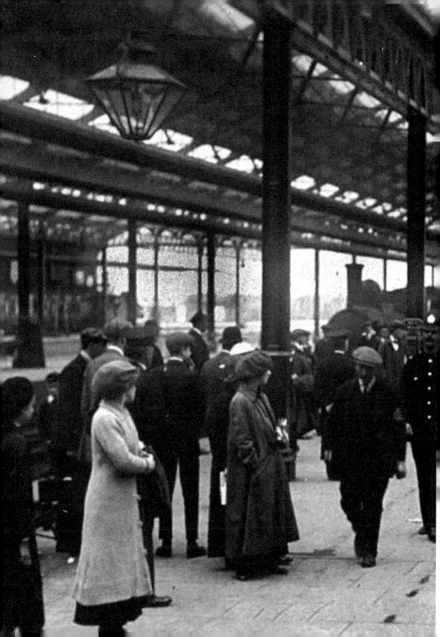

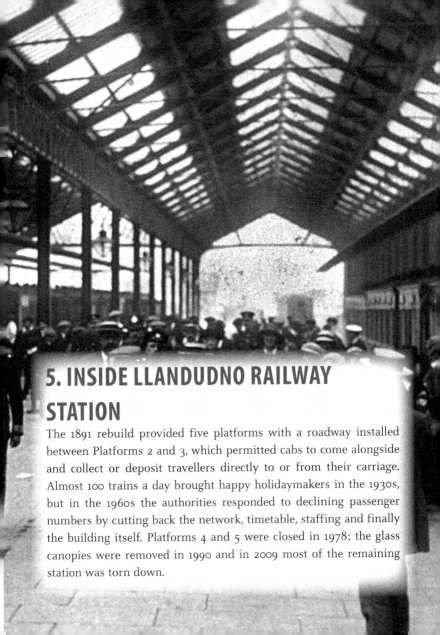

5. INSIDE LLANDUDNO RAILWAY STATION

The 1891 rebuild provided five platforms with a roadway installed between Platforms 2 and 3, which permitted cabs to come alongside and collect or deposit travellers directly to or from their carriage. Almost 100 trains a day brought happy holidaymakers in the 1930s, but in the 1960s the authorities responded to declining passenger numbers by cutting back the network, timetable, staffing and finally the building itself. Platforms 4 and 5 were closed in 1978; the glass canopies were removed in 1990 and in 2009 most of the remaining station was torn down.

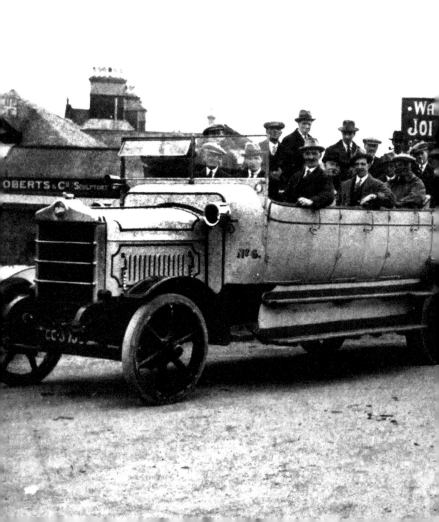

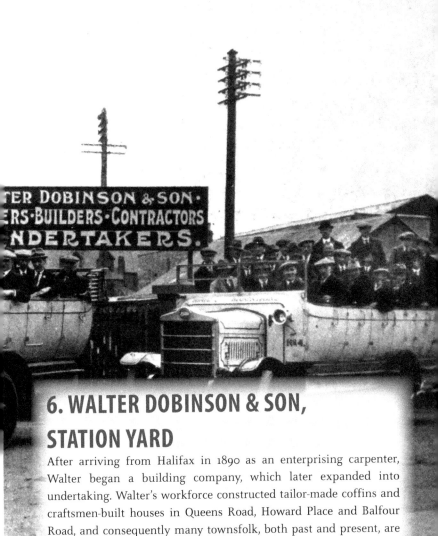

6. WALTER DOBINSON & SON, STATION YARD

After arriving from Halifax in 1890 as an enterprising carpenter, Walter began a building company, which later expanded into undertaking. Walter's workforce constructed tailor-made coffins and craftsmen-built houses in Queens Road, Howard Place and Balfour Road, and consequently many townsfolk, both past and present, are currently accommodated in one or other of Dobinson's products.

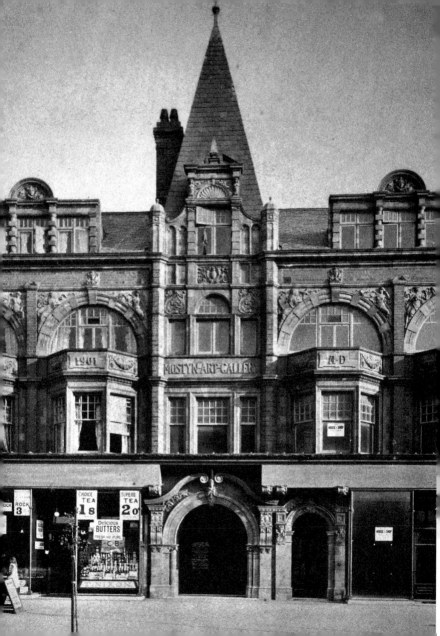

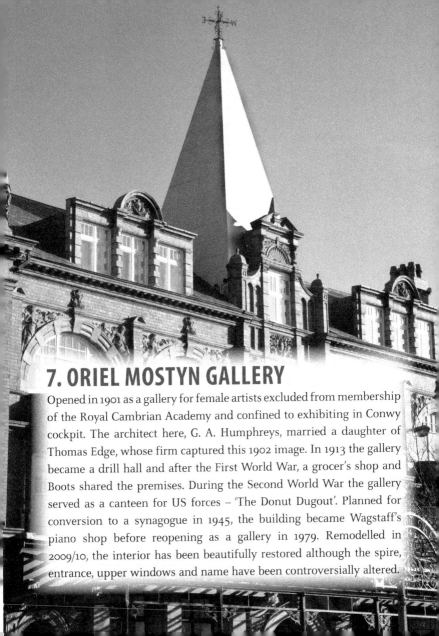

7. ORIEL MOSTYN GALLERY

Opened in 1901 as a gallery for female artists excluded from membership of the Royal Cambrian Academy and confined to exhibiting in Conwy cockpit. The architect here, G. A. Humphreys, married a daughter of Thomas Edge, whose firm captured this 1902 image. In 1913 the gallery became a drill hall and after the First World War, a grocer's shop and Boots shared the premises. During the Second World War the gallery served as a canteen for US forces – 'The Donut Dugout'. Planned for conversion to a synagogue in 1945, the building became Wagstaff's piano shop before reopening as a gallery in 1979. Remodelled in 2009/10, the interior has been beautifully restored although the spire, entrance, upper windows and name have been controversially altered.

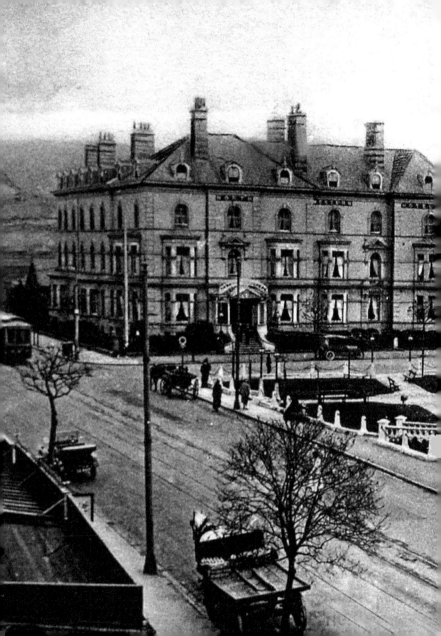

8. TUDNO CASTLE HOTEL

Today, traffic no longer encircles the gardens and modern buildings have encroached to both the right and rear of the hotel. The gentleman descending the steps to the public conveniences must now follow an alternative route as must tram passengers since that service was withdrawn in 1956. Even the iconic Tudno Castle Hotel, designed by George Felton and erected in 1862, is planned for redevelopment.

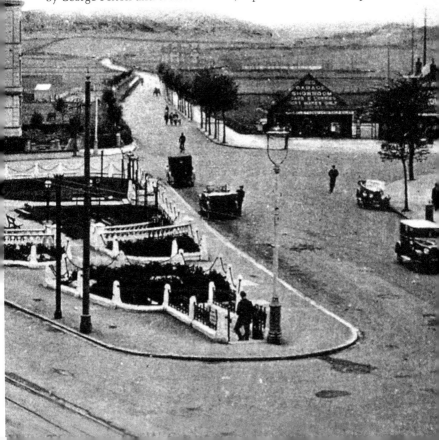

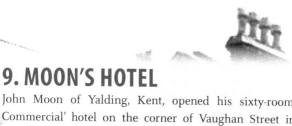

9. MOON'S HOTEL

John Moon of Yalding, Kent, opened his sixty-room 'Family & Commercial' hotel on the corner of Vaughan Street in the 1870s. Taken over by T. P. Myler, the original name was retained until the early 1930s. 'Under new management' the hotel was then modernised both inside and out with some of the external classical detailing sacrificed to create ground floor retailing, corner bay windows and enlarged attic rooms. With the name modernised to the 'Broadway', its founder was finally eclipsed.

FAMILY
COMMERCIAL
HOTEL.

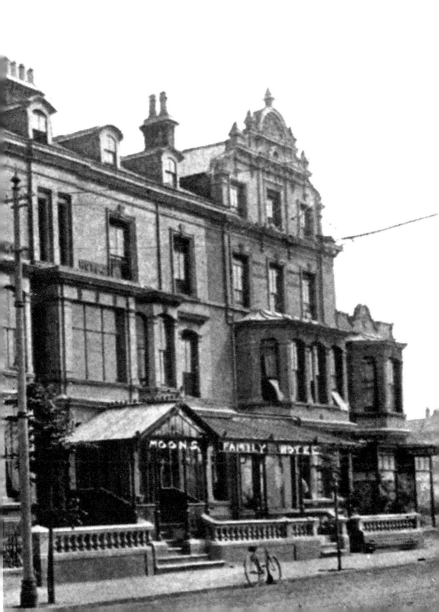

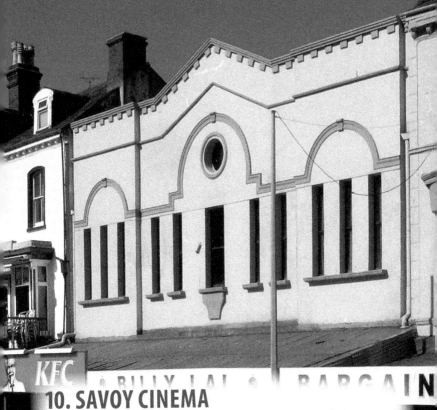

10. SAVOY CINEMA

In August 1914, Llandudno's first purpose-built cinema opened on the site of the old Royal Oak Hotel. Designed by local architect Arthur Hewitt following the installation of sound equipment in 1932 the cinema was renamed the Savoy. After a serious wartime fire the Savoy closed on 4 June 1942. Repaired and unattractively modernised, it eventually reopened in August 1955 as the New Savoy Cinema. After audiences declined, the cinema finally closed in October 1986 and was demolished. As a token gesture to conservationists the façade of its replacement was designed to evoke something of the site's former glory.

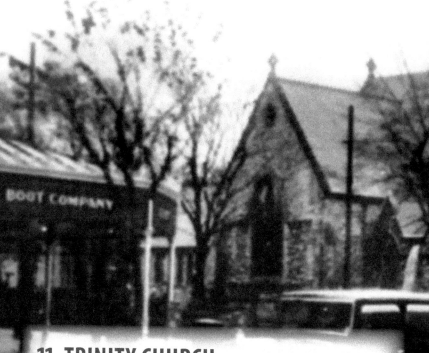

11. TRINITY CHURCH

This photograph was taken on Sunday 30 October 1932. With high seas and stormy weather, 'as early as 9 a.m. the tide had reached the top of the promenade steps', and by 10 a.m. it was washing over the parade; by noon the wind was driving huge waves on to both north and west shores sending rivers of water into town and creating a huge lake around Trinity church. The *Llandudno Advertiser* reported that the chairman of the council, Mr R. C. Baxter, was driving past the church when his engine died and he had to be rescued by another passing motorist, Dr John Reay (father of the author).

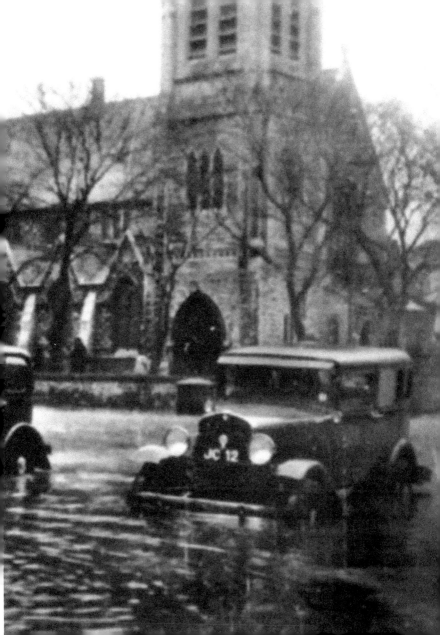

12. BUNNEY'S STORE, NOs 47–51 MOSTYN STREET

In 1888, Liverpool fancy goods dealer Alfred Henry Bunney opened an 'American Bazaar' on Mostyn Street. His Llandudno shop became so familiar that this intersection with Clonmel Street is still popularly referred to as 'Bunney's Corner'. Stocking everything from clocks to cutlery and toys to toiletries, Bunney's also published and sold postcards. In December 1987, a few months short of its centenary, Bunney's was demolished and replaced by a modern pastiche complete with 'rocket tower' supposedly echoing the Alexandra Hotel on the corner opposite.

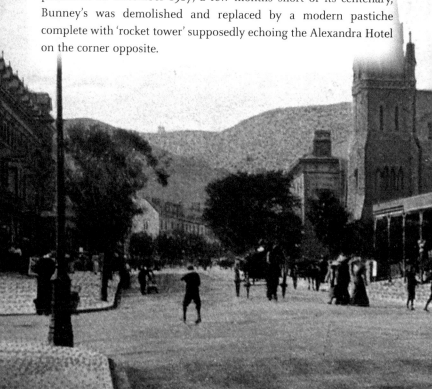

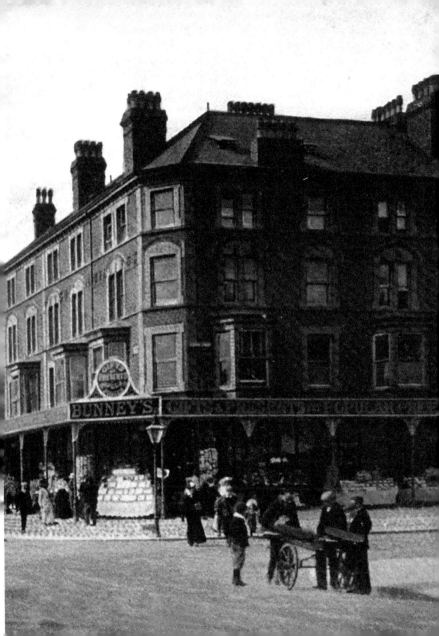

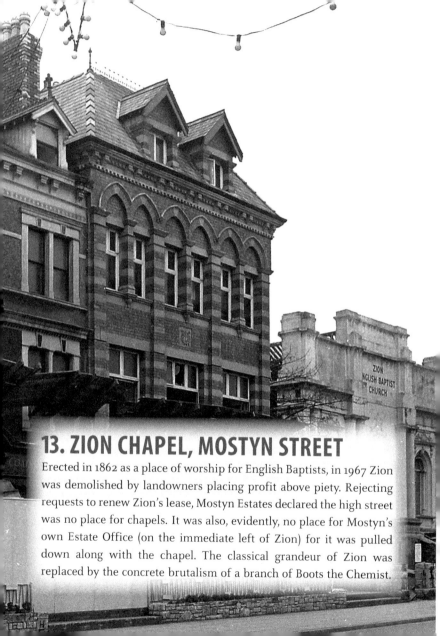

13. ZION CHAPEL, MOSTYN STREET

Erected in 1862 as a place of worship for English Baptists, in 1967 Zion was demolished by landowners placing profit above piety. Rejecting requests to renew Zion's lease, Mostyn Estates declared the high street was no place for chapels. It was also, evidently, no place for Mostyn's own Estate Office (on the immediate left of Zion) for it was pulled down along with the chapel. The classical grandeur of Zion was replaced by the concrete brutalism of a branch of Boots the Chemist.

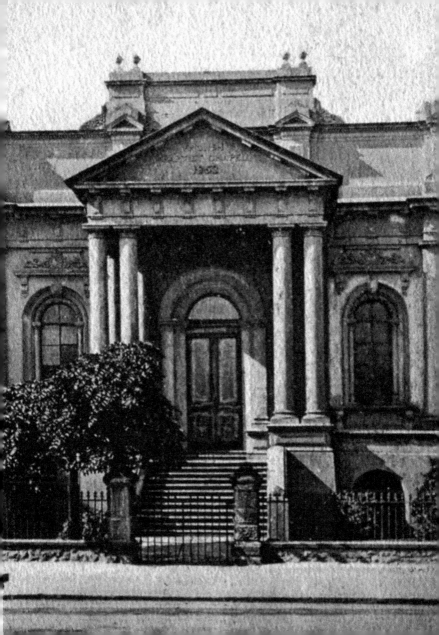

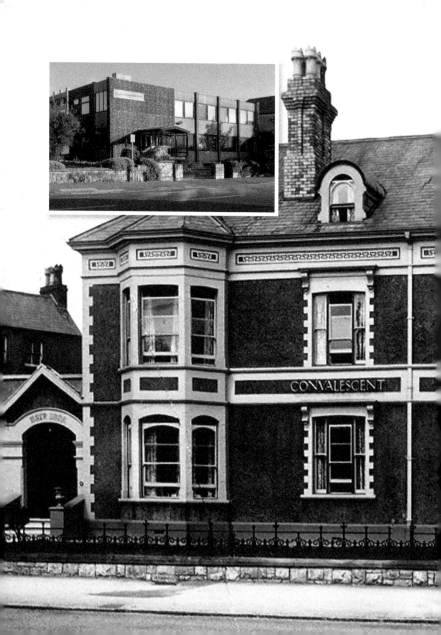

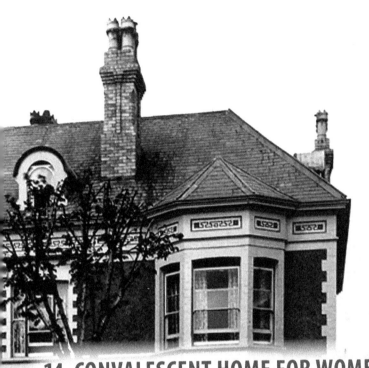

14. CONVALESCENT HOME FOR WOMEN (EIVION & BRYN EGLWYS)

Garden squares are an essential ingredient of planned towns of any architectural ambition and Trinity Square is Llandudno's best attempt. The surviving Victorian villas evoke an era of solid respectability, with Drummond Villa (across the road) appropriately accommodating the regional headquarters of the National Trust, but cowering in the square's south-western corner is one of Llandudno's more regrettable examples of architectural 'improvement'. In the 1960s this rebuilding was promoted by George Hiller, the Mostyn agent, as part of his 'transformation of a tired holiday town'.

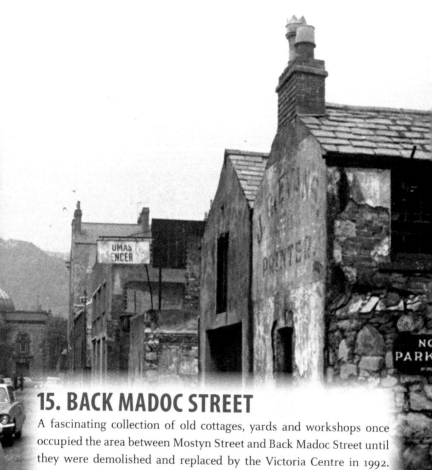

15. BACK MADOC STREET

A fascinating collection of old cottages, yards and workshops once occupied the area between Mostyn Street and Back Madoc Street until they were demolished and replaced by the Victoria Centre in 1992. A variety of Llandudno trades, from undertakers to mineral water manufacturers, operated here. However, by the 1960s Back Madoc Street was in decline. The early origins of the foreground cottage are revealed by its limestone construction, while its 1920s use as a print shop run by local-born John Robert Evans is recorded on its gable end.

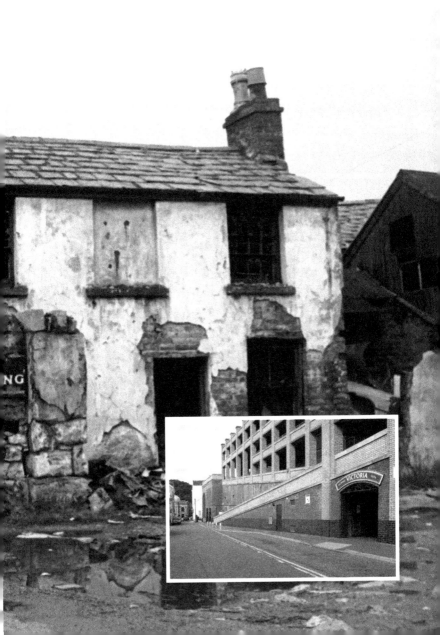

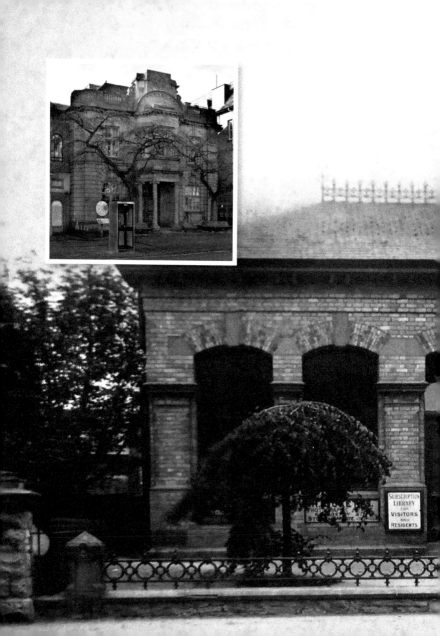

SUBSCRIPTION
LIBRARY
for
VISITORS
and
RESIDENTS

16. PUBLIC LIBRARY, NO. 44 MOSTYN STREET

Llandudno's first semi-public library opened in 1855 in the Baths, North Parade, but as the town grew this proved inadequate and this attractive single-storey newsroom and library was opened on Mostyn Street in 1873. Subscriptions were required to use the library, but along with books the building offered art classes, photographic dark rooms, billiards and a museum. Once again, Llandudno outgrew its library and in 1910 a new enlarged free library, designed by G. A. Humphreys, was erected on the site.

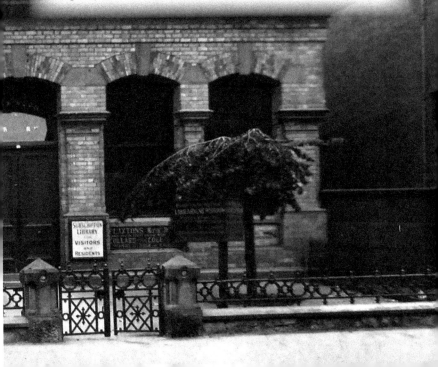

17. MARKS & SPENCER, NO. 61 MOSTYN STREET

When the original (lighter-coloured) Marks & Spencer building was erected in 1936 its stark modernist design was denounced as an inappropriate intrusion into Mostyn Street. Ironically, when it expanded eastwards in 1973 it incorporated a rebuilt bank that had received a similarly frosty reception when first erected in 1923. It wasn't the design of the original bank that offended so much as its position which was attached to the old manse to St John's Wesleyan Methodist church – an unwelcome example of God giving way to Mammon.

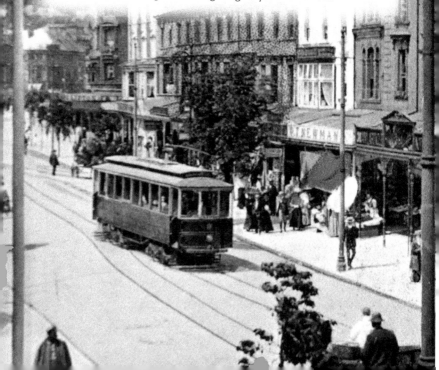

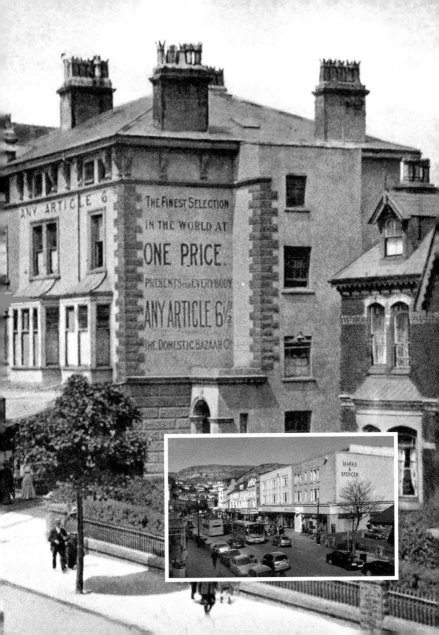

THE FINEST SELECTION
IN THE WORLD AT
ONE PRICE.
PRESENTS FOR EVERYBODY
ANY ARTICLE 6½
THE DOMESTIC BAZAAR Cº

ANY ARTICLE 6

MARKS AND SPENCER

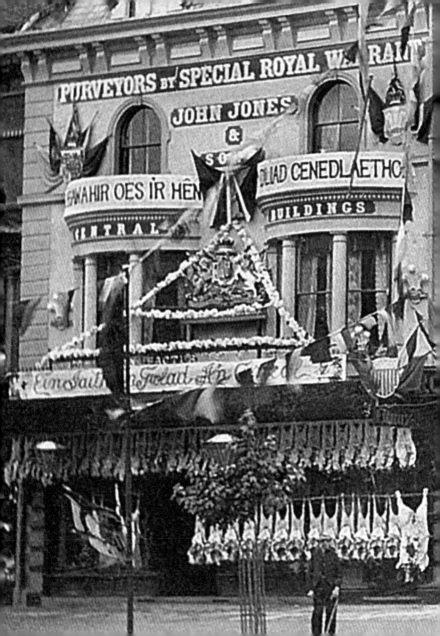

18. JOHN JONES'S BUTCHER'S SHOP, NO. 56 MOSTYN STREET

Established in 1865 in the original Gloddaeth Street market, John Jones boasted celebrity customers as his unique selling point – 'Patronised by Royalty and the Leading Aristocracy'. To maintain his reputation for quality meat, Jones bought in and grazed his own cattle and even invited the public to view production of his celebrated Royal Sandringham Sausages. As supplier of both sausages and mutton to Queen Victoria he ostentatiously adorned his shopfront with banners proclaiming her 1887 Golden Jubilee. Nowadays, Café Express presents a more muted though not entirely unattractive façade to Mostyn Street.

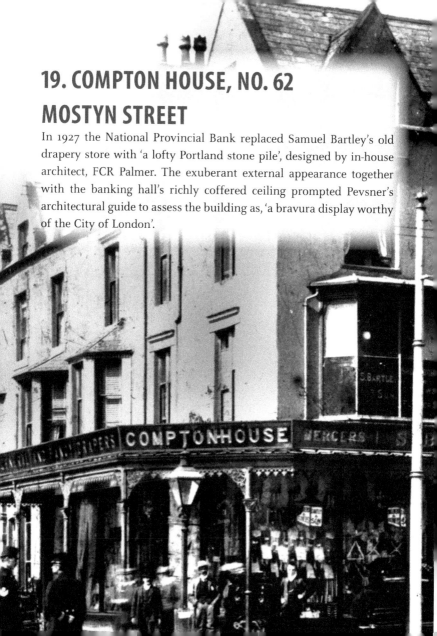

19. COMPTON HOUSE, NO. 62 MOSTYN STREET

In 1927 the National Provincial Bank replaced Samuel Bartley's old drapery store with 'a lofty Portland stone pile', designed by in-house architect, FCR Palmer. The exuberant external appearance together with the banking hall's richly coffered ceiling prompted Pevsner's architectural guide to assess the building as, 'a bravura display worthy of the City of London'.

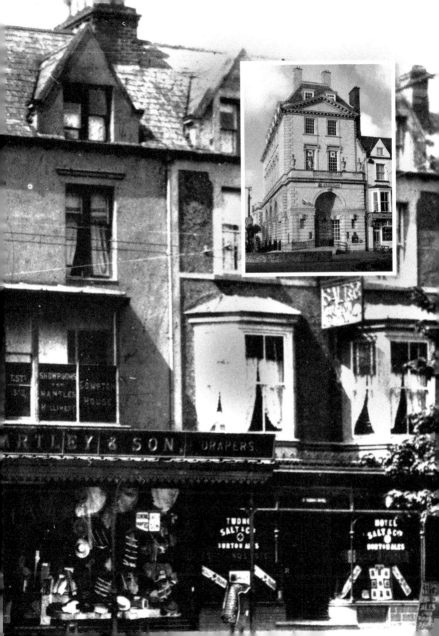

20. LLANDUDNO COCOA HOUSE, NO. 66 MOSTYN STREET

Sarah Annie Reeves Hughes, her husband, Hugh, and their staff are justifiably proud to pose for a photograph outside their temperance hotel and restaurant. For here, at the Cocoa House, on the afternoon of Wednesday 23 January 1907, a group of local women met 'by kind permission of Mrs Reeves Hughes', and 'decided to form a Llandudno Branch of the National Union of Women's Suffrage Societies', the very first active group in the whole of Wales! Although the building continues to offer refreshment, it bears no plaque commemorating its historic significance.

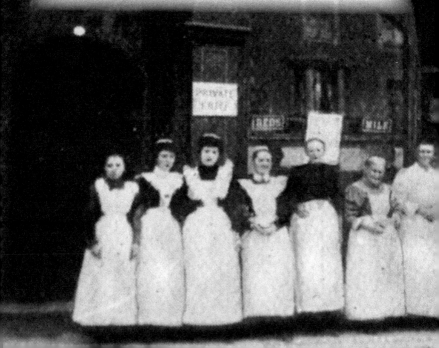

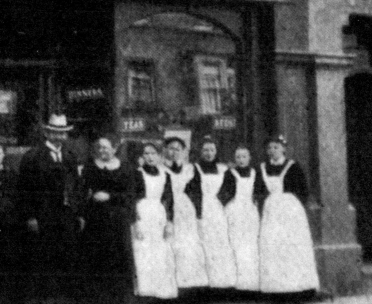

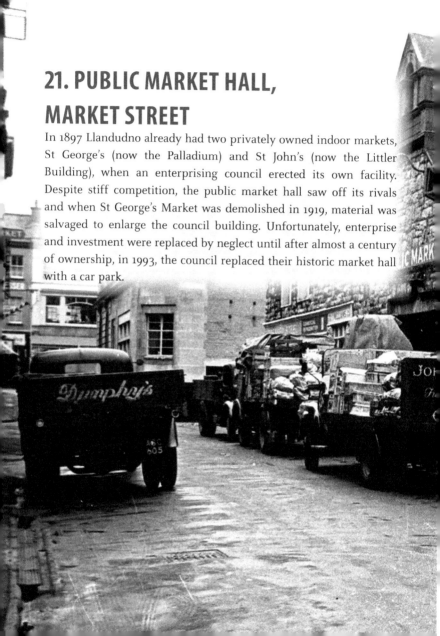

21. PUBLIC MARKET HALL, MARKET STREET

In 1897 Llandudno already had two privately owned indoor markets, St George's (now the Palladium) and St John's (now the Littler Building), when an enterprising council erected its own facility. Despite stiff competition, the public market hall saw off its rivals and when St George's Market was demolished in 1919, material was salvaged to enlarge the council building. Unfortunately, enterprise and investment were replaced by neglect until after almost a century of ownership, in 1993, the council replaced their historic market hall with a car park.

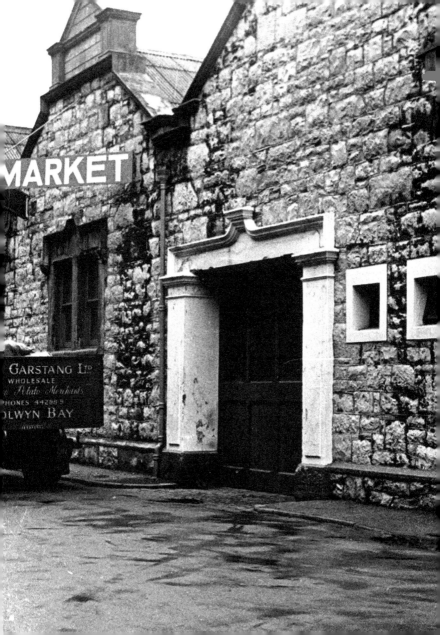

22. WINTER GARDENS, GLODDAETH STREET

In 1934 the Winter Gardens were erected on the site of the former Creams' Coach Garage and multistorey car park by Rochdale-born brothers, James and Zachary Brierley, whose family fortune came from pork pies. Originally the site had been The Vineyard – a walled market garden. Plans for the Winter Gardens were devised by local architect Arthur Hewitt, who included offices for the coach company, a ballroom and a cinema run by the Odeon chain. Closed down in 1986 and demolished in 1989, an unexceptional block of flats now occupies the site.

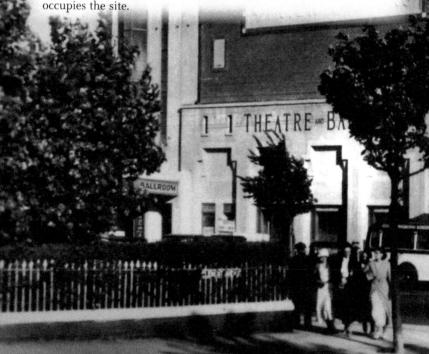

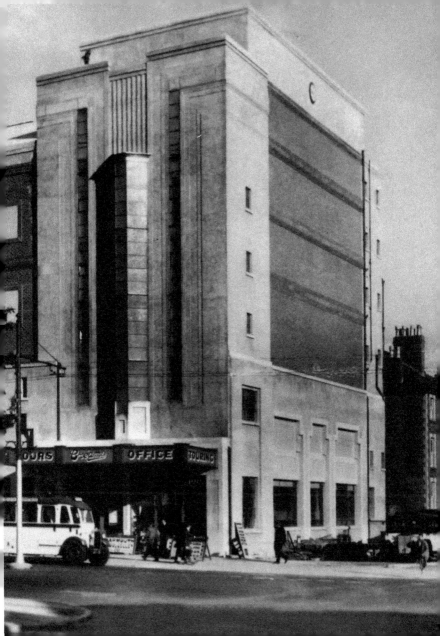

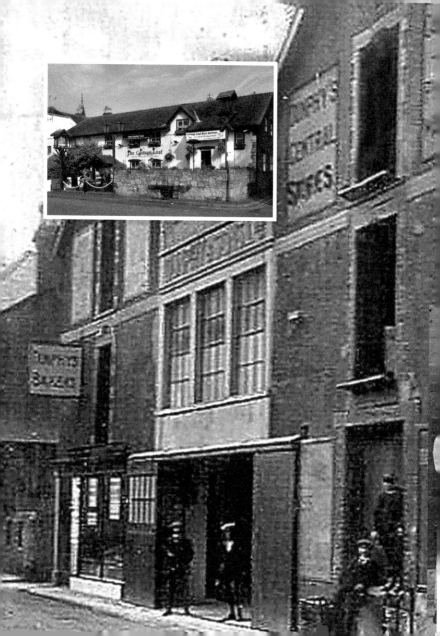

23. DUNPHY'S WAREHOUSE, MARKET STREET

Dunphy's bakery business began in Back Mostyn Street in 1850 before moving into the large building on the left, bearing the Guinness adverts. This bakery-warehouse eventually serviced a chain of Dunphy's stores and employees in the Edwardian era included Joe Taylor (*seated front row, left*), a black Welshman who ran a boxing club in Back Madoc Street. From 1891 until 1912 the *Llandudno Advertiser* was also printed here, on the first floor. Demolished in 1981, the old ship's timber beams from the warehouse were reused in constructing the Cottage Loaf public house, which now occupies the site.

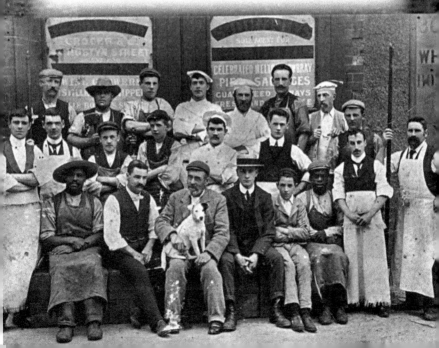

24. ROYAL FISH STORES, NO. 68 MOSTYN STREET

'If It Swims We Sell It' was the proud boast of Llanrwst-born Richard Roberts, a piscatorial pioneer whose business, founded by father-in-law Edward Foulkes in 1864, traded in Llandudno for more than a century. Until closure in the 1960s, Roberts proclaimed their Royal Warrant, 'Purveyors of Fish to the Royal Court of Romania', a legacy of serving the Queen of Romania (Carmen Sylva) when she holidayed in Llandudno in 1890. Fortunately, conversion of the premises into the Midland Bank (now HSBC) retained and perhaps enhanced the architectural appeal of the building.

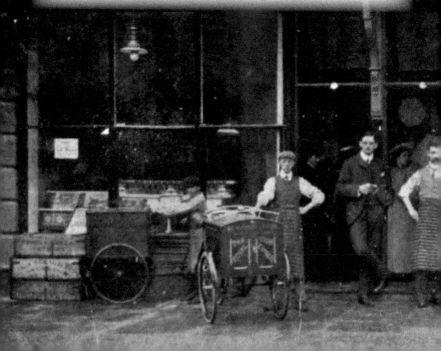

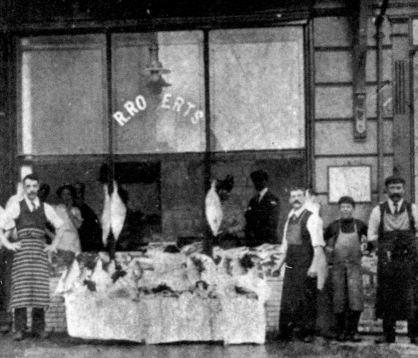

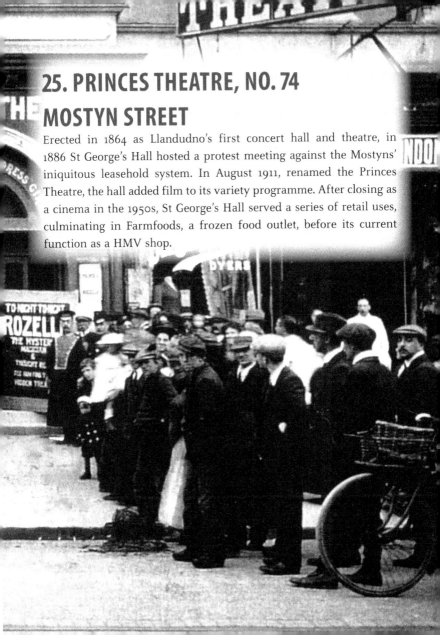

25. PRINCES THEATRE, NO. 74 MOSTYN STREET

Erected in 1864 as Llandudno's first concert hall and theatre, in 1886 St George's Hall hosted a protest meeting against the Mostyns' iniquitous leasehold system. In August 1911, renamed the Princes Theatre, the hall added film to its variety programme. After closing as a cinema in the 1950s, St George's Hall served a series of retail uses, culminating in Farmfoods, a frozen food outlet, before its current function as a HMV shop.

26. PALLADIUM, GLODDAETH STREET

Designed by Wehnert & Ashdown of Charing Cross and erected in 1857, the market hall was rebuilt and enlarged several times in the Victorian era. In February 1919 it was acquired and demolished by a consortium of local businessmen intent on replacing it with 'a large high-class music hall and picture theatre'. Cllr Arthur Hewitt was architect on the project, Arthur Thorpe the main contractor with electrics installed by Cllr Ernest Lane and seating fitted by Cllr Frank Dickens. The Palladium opened on Monday 2 August 1920 although building work wasn't quite finished. Members of the audience perched on planks and 'the pictures were frankly a failure with gaps in the front of the building letting in so much light that it was difficult to discern the film ... but the variety turns were good.'

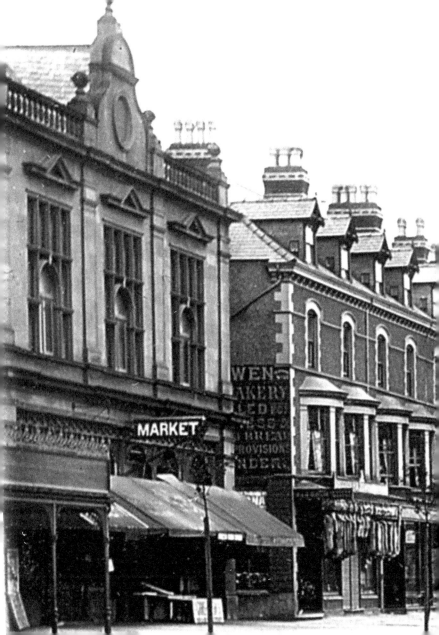

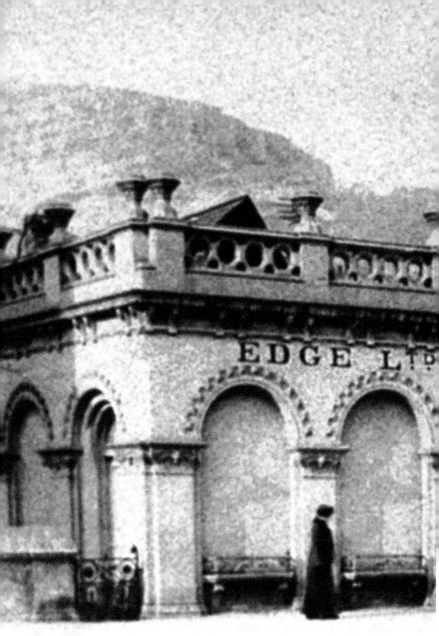

27. THOMAS EDGE'S PHOTOGRAPHIC STUDIO, NOS 8–12 GLODDAETH STREET

Converted to a parade of shops, the former photographic studios have remained one-storey high – an aspect commended in Edge's original advertising as 'elderly people and invalids need not fear the fatigue of mounting high flights of stairs.' Edge was an innovator, 'the first in Europe to introduce the American principle of enlarging photographs by electric light'. He was also an artist who painted 'miniatures in watercolours, beautifully and artistically finished for lockets, bracelets etc.' Visiting celebrities patronised his studio and in 1987 an early Edge *carte-de-visite* of Sir and Lady Monier-Williams was purchased by the National Portrait Gallery.

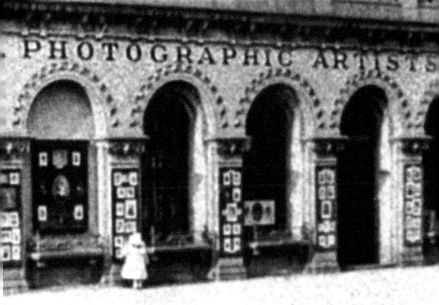

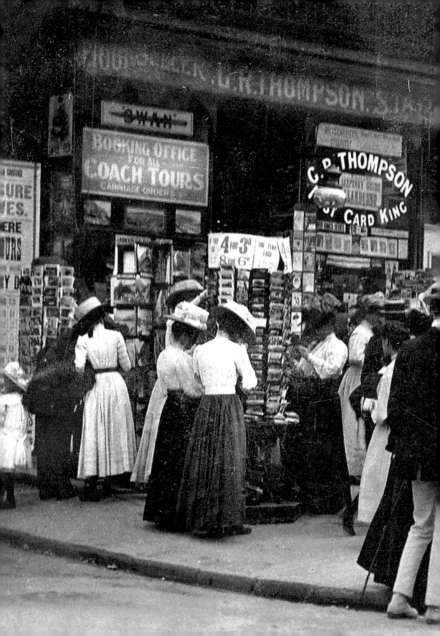

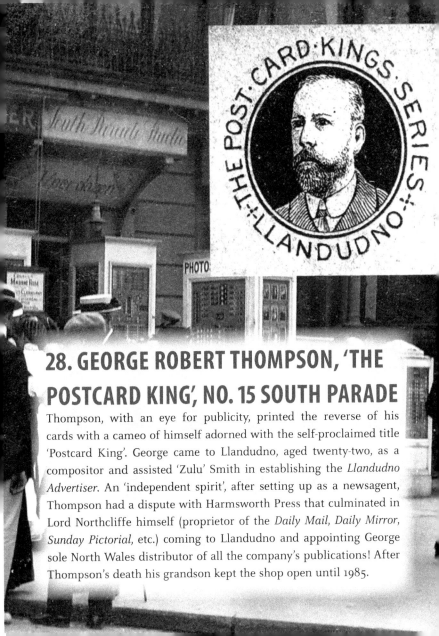

28. GEORGE ROBERT THOMPSON, 'THE POSTCARD KING', NO. 15 SOUTH PARADE

Thompson, with an eye for publicity, printed the reverse of his cards with a cameo of himself adorned with the self-proclaimed title 'Postcard King'. George came to Llandudno, aged twenty-two, as a compositor and assisted 'Zulu' Smith in establishing the *Llandudno Advertiser*. An 'independent spirit', after setting up as a newsagent, Thompson had a dispute with Harmsworth Press that culminated in Lord Northcliffe himself (proprietor of the *Daily Mail*, *Daily Mirror*, *Sunday Pictorial*, etc.) coming to Llandudno and appointing George sole North Wales distributor of all the company's publications! After Thompson's death his grandson kept the shop open until 1985.

29. UPPER MOSTYN STREET

Upper Mostyn Street hasn't changed since it was laid out in the 1850s, but there have been many minor changes. As mining and quarrying faded into distant memory, the hillside has become increasingly clothed in vegetation. The street is now dominated by motor vehicles dissuading pedestrians from dallying on the roadway and the iron awnings, so characteristic of Llandudno, and which formed no part of the original plans, were only just putting in an appearance.

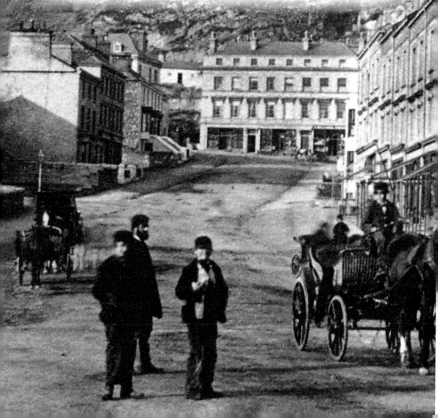

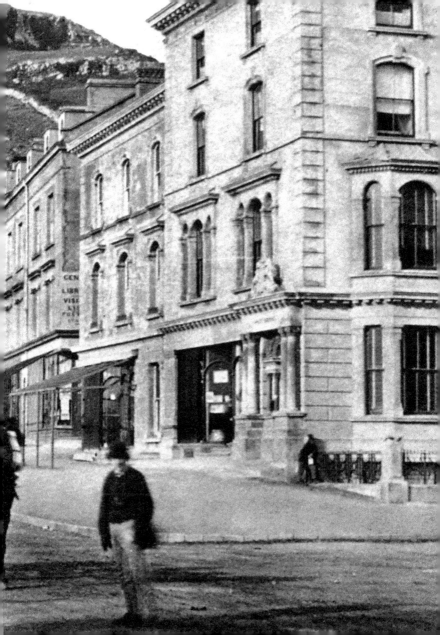

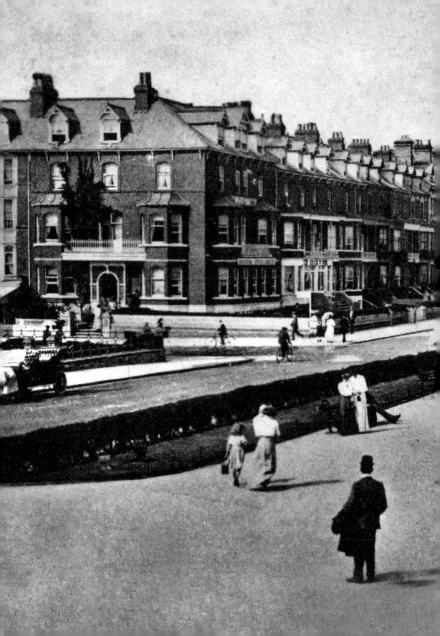

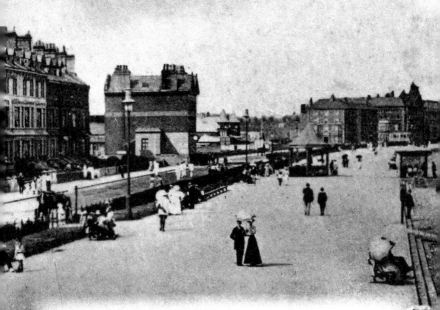

30. PROMENADE

There are four striking changes from the Edwardian view. Bathing machines have disappeared, the stylish glass and iron Victorian beach shelter has been replaced by an ugly concrete shed, thousands of tons of rocks have been dumped on to the beach limiting erosion but making access to sea difficult and uncomfortable, and unlike Edwardian holidaymakers we no longer value promenading as a social occasion worthy of elegant dress.

31. TY UNNOS ON THE MORFA

Before the railway arrived, Llandudno was an isolated Welsh-speaking community. Most villagers lived on the Great Orme, but lining the picturesque bay was a small hamlet of whitewashed *tai unnos* or overnight houses. These cottages had been erected overnight on community land by homeless families following a Welsh tradition that recognised their right to remain. Llandudno landlord Edward Lloyd Mostyn MP resented squatters spoiling his development plans and in 1843 used his parliamentary position to remove the inconvenience.

32. PRINCE EDWARD SQUARE, FROM GREAT ORME HEADLAND

Francis Bedford's panorama records much of the resort as originally planned with the seaside still largely undeveloped. While the attractive terraces survive, architecturally inferior buildings have invaded both background and fore. The 1922 erection of the Colwyn-Foulkes designed war memorial, a 50-foot obelisk of Cornish granite, in the key space of Prince Edward Square is an honourable exception. Sadly, names continue to be added to the monument, most recently Lance Bombardier Llywelyn Evans, killed on the first day of Prime Minister Blair's 2003 attack on Iraq.

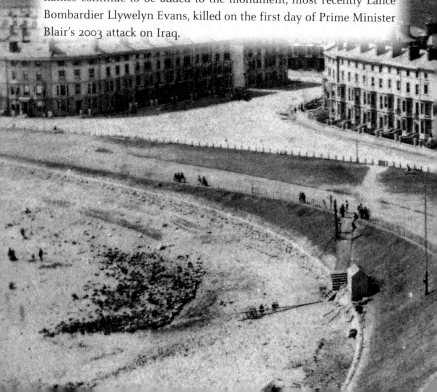

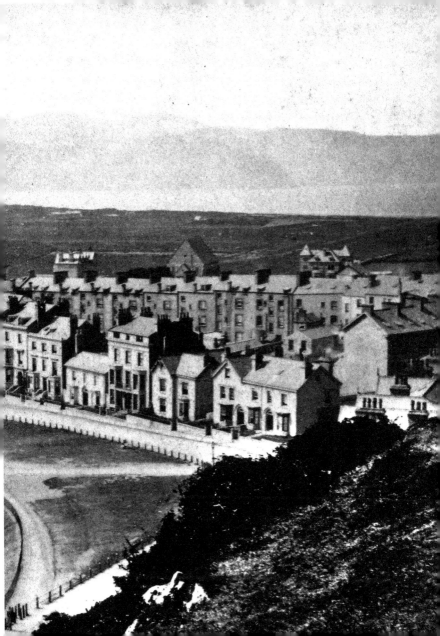

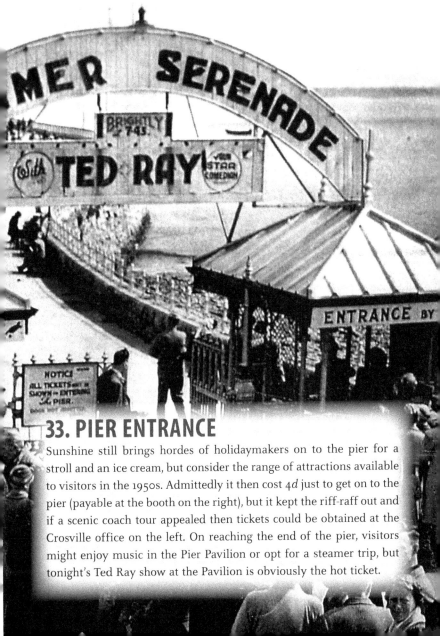

33. PIER ENTRANCE

Sunshine still brings hordes of holidaymakers on to the pier for a stroll and an ice cream, but consider the range of attractions available to visitors in the 1950s. Admittedly it then cost 4*d* just to get on to the pier (payable at the booth on the right), but it kept the riff-raff out and if a scenic coach tour appealed then tickets could be obtained at the Crosville office on the left. On reaching the end of the pier, visitors might enjoy music in the Pier Pavilion or opt for a steamer trip, but tonight's Ted Ray show at the Pavilion is obviously the hot ticket.

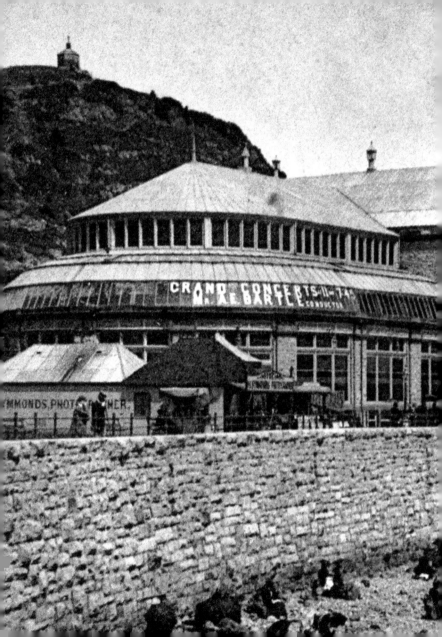

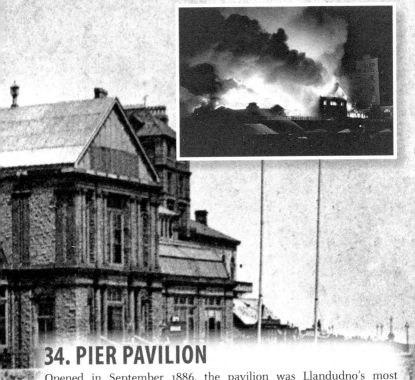

34. PIER PAVILION

Opened in September 1886, the pavilion was Llandudno's most ambitious, elegant and extraordinary building. This amazing stone, iron and glass confection offered orchestras, cinema, pantomime and political conferences while an adjacent building housed Symonds' photographic studio. Adelina Patti, George Formby, Paul Robeson, Oswald Moseley, Arthur Askey and Margaret Thatcher all performed here, although, regrettably, never on the same bill! The illustrious history of the Pier Pavilion ended, spectacularly, in flames, on the evening of Sunday 13 February 1994 in an unsolved act of arson.

35. EMPIRE HOTEL, CHURCH WALKS

Thomas Williams opened the town's first department store in 1854, offering a far wider range of items than the proverbial needle-to-an-anchor. Products on sale at his emporium included Atkinson's Bear Grease, fresh German leeches, Dr Erasmus Wilson's Hair Wash, gunpowder, Oriental Toothpaste, fire insurance and Llandudno's first Visitor's Handbook. Converted to a hotel in 1904, the Empire has since been extended and modernised yet retains much of the building's original character.

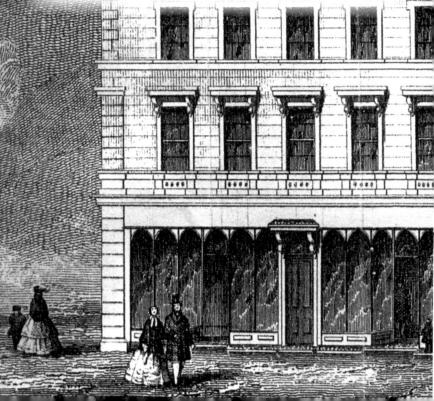

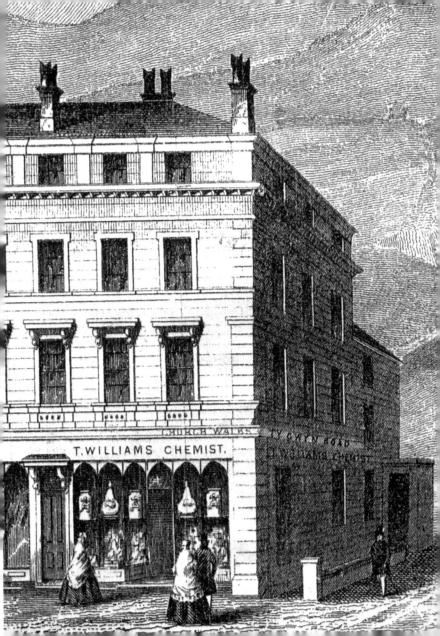

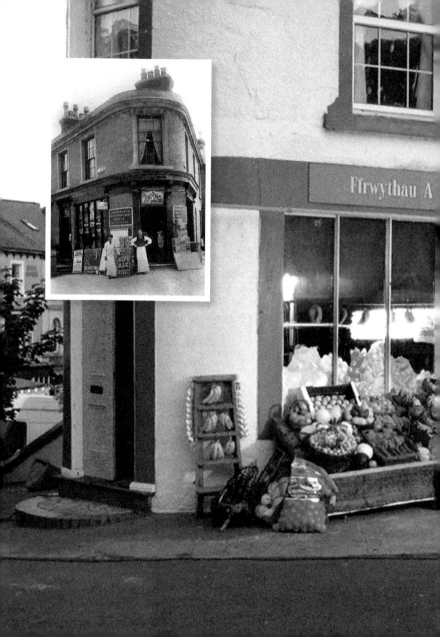

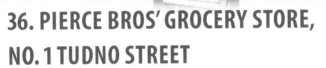

36. PIERCE BROS' GROCERY STORE, NO. 1 TUDNO STREET

When this building was erected in the late 1850s it stood at the commercial centre of the new resort. In the closing years of the nineteenth century, farmer's sons Edward and younger brother Robert Pierce moved here from Llanefydd, Denbighshire, to open a grocery store. By then the premises were already rather on the edge of the main shopping area, which has continued to shift inexorably east. In 2009 the building's unusual flat-iron shape and attractive Victorian appearance offered filmmakers an ideal setting for *Blodau*, a six-part S4C television series following the lives of best friends who take over a fruit and vegetable store and transform it into a flower shop.

37. VARDRE LANE ARCH

Back North Parade until 1910, the original name hints at the service function of the area beyond the arch. Stabling predominated and this marvellous architectural flourish was intended to evoke the classical grandeur of gentry coach houses. Erected around 1855 by Thomas Owen, who also built St George's Hotel, it is intolerable that such an elegant feature should suffer such philistine damage and neglect.

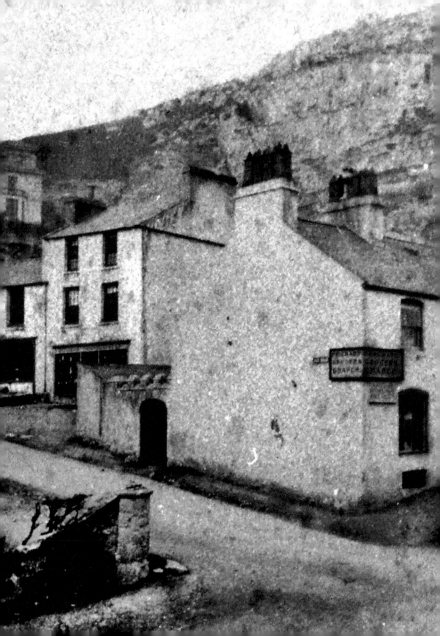

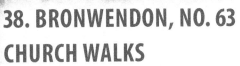

38. BRONWENDON, NO. 63
CHURCH WALKS

Before the development of the modern resort, William Pritchard's cottage served as Llandudno's main emporium (photographed here by James Cornaby). Opened in 1831, the range of merchandise included tincture of rhubarb, frying pans, hats, blasting powder, groceries and medical advice. Eclipsed in 1854 by the opening of Thomas Williams' superstore (now the Empire Hotel), in the late Victorian era, Bronwendon was enlarged and began operating as a guesthouse.

39. KING'S HEAD, OLD ROAD

The only pub in Llandudno surviving from the days before the bathing resort, the King's Head was a popular meeting place for copper miners and a convenient centre for distributing their wages. In the late eighteenth and early nineteenth centuries the ground at the back of the pub served as an unofficial village square. The original part of the inn, on the left, was extended in the late nineteenth century and although the corner entrance was later converted to a window, the building retains much of its attractive historic character.

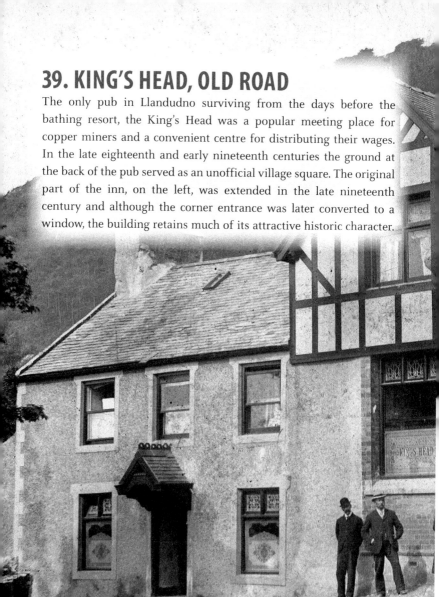

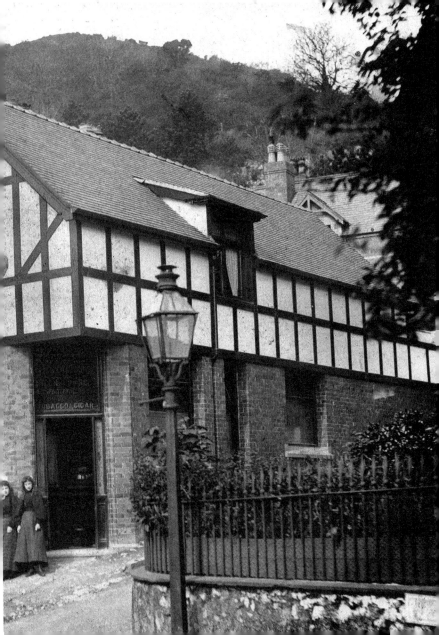

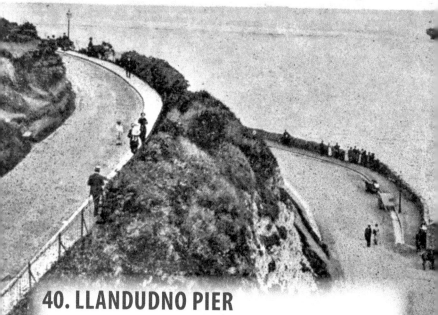

40. LLANDUDNO PIER

Opened on 1 August 1877, Llandudno's pier was constructed by John Dixon who designed the floating iron cylinder-case that brought Cleopatra's Needle to Britain. The original pier office survives but now dispenses fishing tackle rather than entrance tickets. The wonderful 185-yard-long elevated walkway (on the left) leads into Happy Valley. Designed by G. A. Humphreys in a 'concrete classical' style and opened to huge public acclaim in April 1932, the colonnade now stands shamefully neglected and unappreciated.

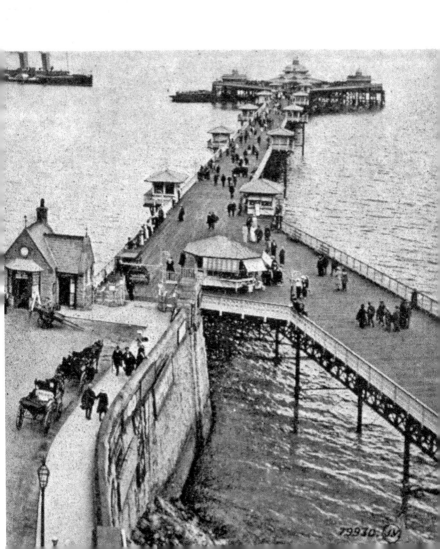

79930. JV

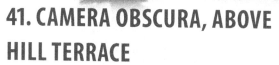

41. CAMERA OBSCURA, ABOVE HILL TERRACE

In 1860 one of Llandudno's first postmen, Lot Williams (1841–1919), erected a periscopic device on a hill above Happy Valley. Williams entertained paying entrants to his 'magic shed' with living panoramas of the town below. A moving image of Llandudno life was cast on to a circular screen inside the building by a mirror and lens mounted on the roof. In 1966, the original device was burnt down by vandals but was rebuilt a couple of years later by local taxi-driver and enthusiast Jackie Shields. With only seven surviving examples in Britain, Llandudno's camera obscura is a rare and historic attraction.

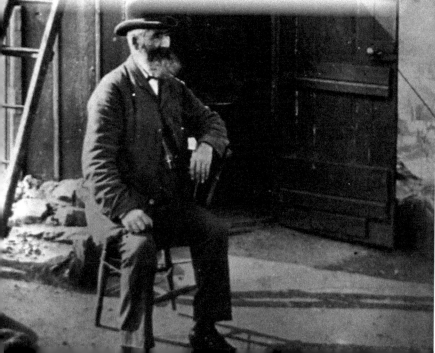

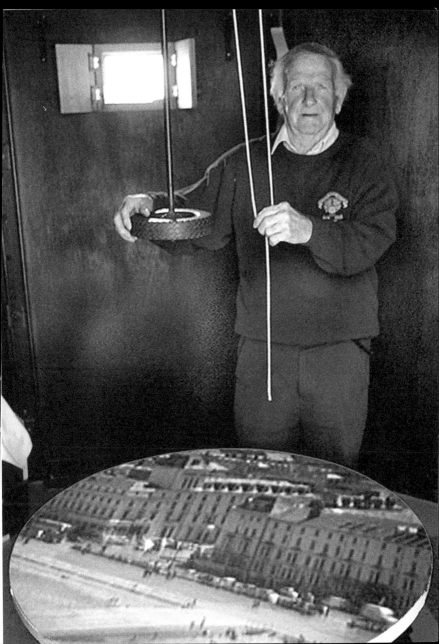

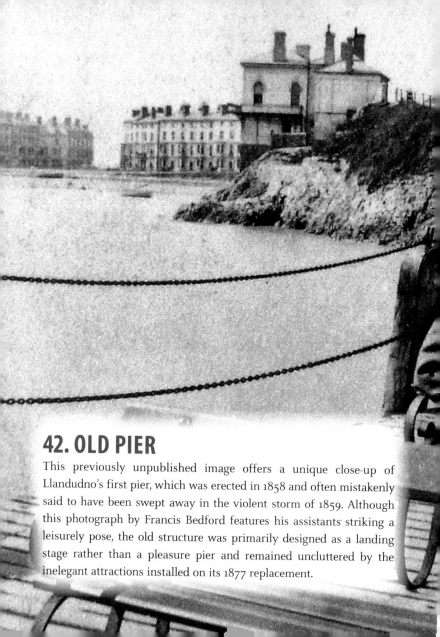

42. OLD PIER

This previously unpublished image offers a unique close-up of Llandudno's first pier, which was erected in 1858 and often mistakenly said to have been swept away in the violent storm of 1859. Although this photograph by Francis Bedford features his assistants striking a leisurely pose, the old structure was primarily designed as a landing stage rather than a pleasure pier and remained uncluttered by the inelegant attractions installed on its 1877 replacement.

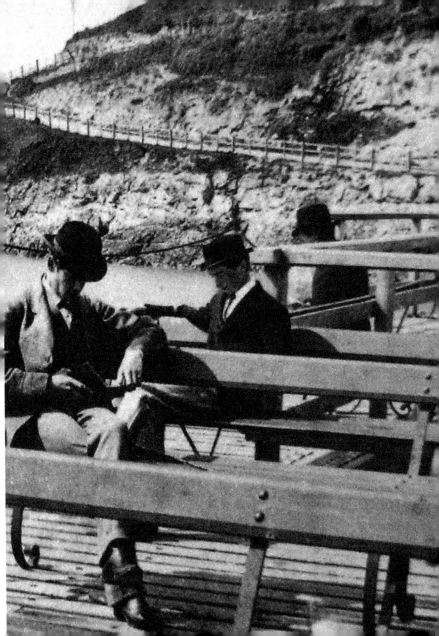

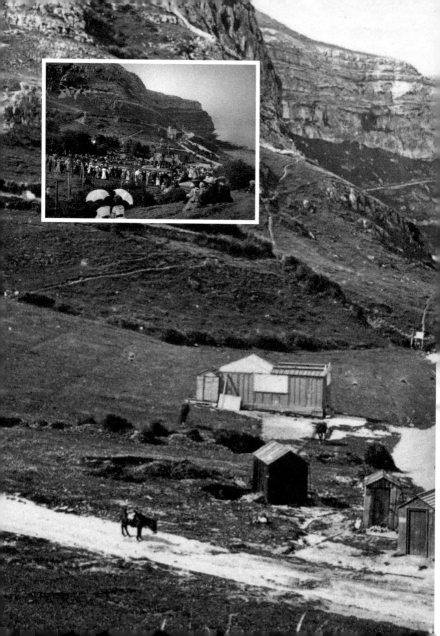

43. HAPPY VALLEY

Happy Valley was first coined to promote this attractive dell in 1855, with a range of organised outdoor entertainments – musical, religious, bardic and theatrical – on offer since at least 1872. Performers initially operated from tents until the charming bijou theatre depicted in the inset image was erected in the Edwardian era. Rebuilt after a serious fire in 1933, its replacement remained a popular attraction until the late 1970s. The little theatre then stood empty and abandoned for almost a decade before being leased as a refreshment kiosk. The big shed in this larger view arrived from England as a horse-drawn pantechnicon driven by photographer James S. Cornaby, with his wife, Caroline, and equipment inside. Parked in the old Happy Valley quarry from around 1860 to 1880, Cornaby's van then served as his photographic studio. Eventually Cornaby moved on, and to mark the Royal Jubilee the Mostyns closed the quarry and gifted the valley to the town for the creation of a public park. The memorial fountain featuring a bust of Queen Victoria was unveiled in August 1890.

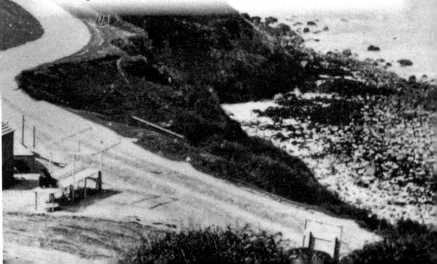

44. THE ROCK STUDIO, MARINE DRIVE

Son of a famous photographer, around 1872, William Sylvester Laroche came to Llandudno to set up on his own studio. In conjunction with conventional facilities at No. 43 Mostyn Street, the enterprising Laroche exploited the picturesque qualities of an old quarry on the Orme, just off the Marine Drive, to create the 'Rock Studio'. Although Laroche died in 1894, the Rock Studio continued to operate with an old tin shed, latterly used for selling souvenirs, remaining on site until the 1950s.

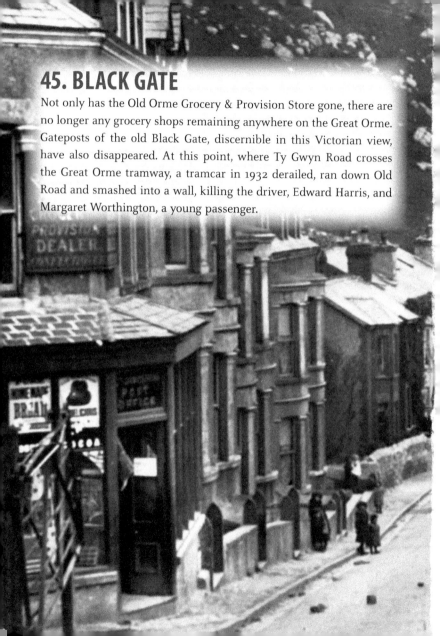

45. BLACK GATE

Not only has the Old Orme Grocery & Provision Store gone, there are no longer any grocery shops remaining anywhere on the Great Orme. Gateposts of the old Black Gate, discernible in this Victorian view, have also disappeared. At this point, where Ty Gwyn Road crosses the Great Orme tramway, a tramcar in 1932 derailed, ran down Old Road and smashed into a wall, killing the driver, Edward Harris, and Margaret Worthington, a young passenger.